ADULT COLORING BOOKS

ART NOUVEAU FASHIONS

Published in the United Kingdom by Individuality Ltd

7 Ascot Close, Borehamwood, Hertfordshire, WD6 3JH

Illustrations © Stephanie Buss 2016 for Individuality Ltd

www.individualitybooks.com

Printed in Great Britain

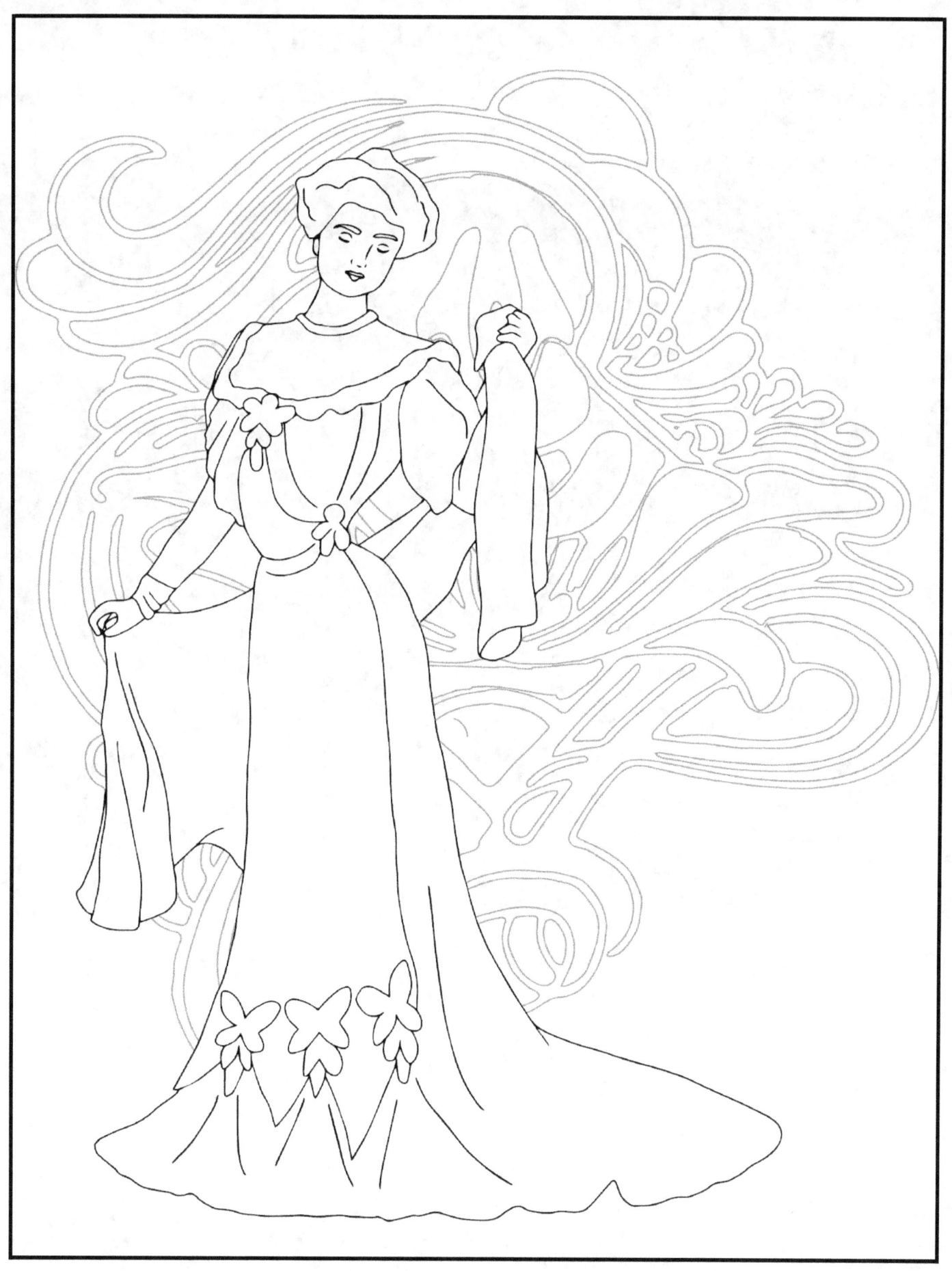

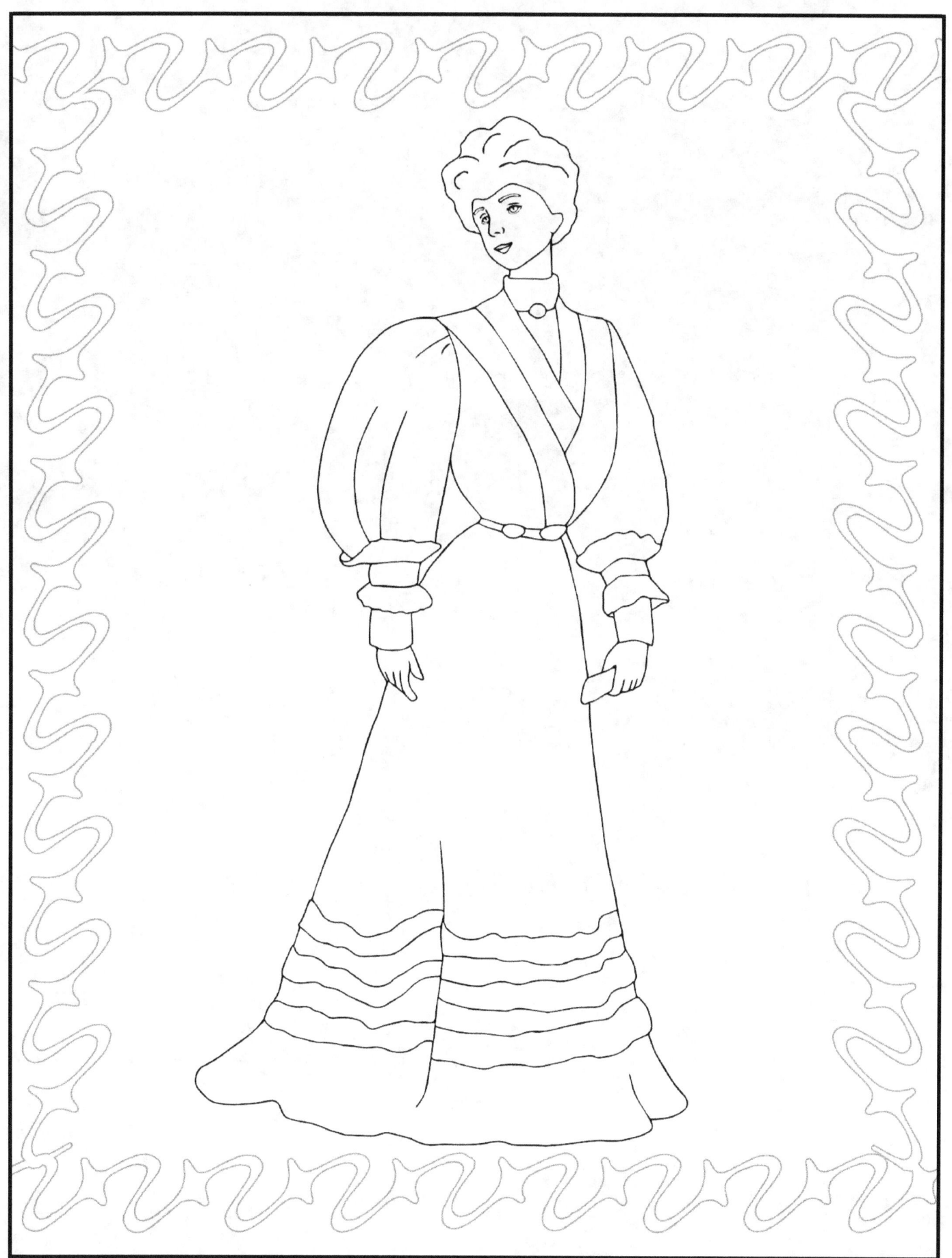

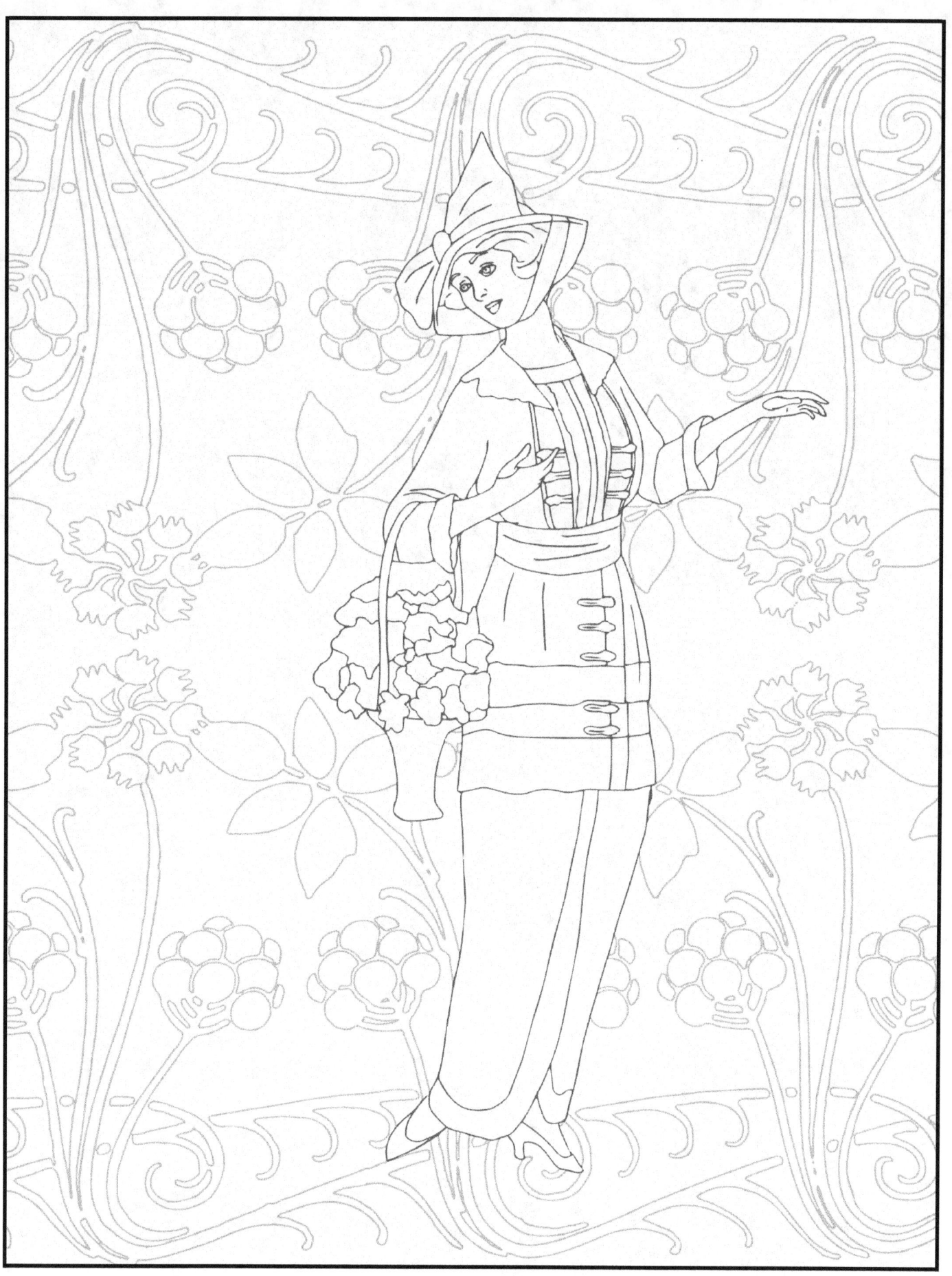

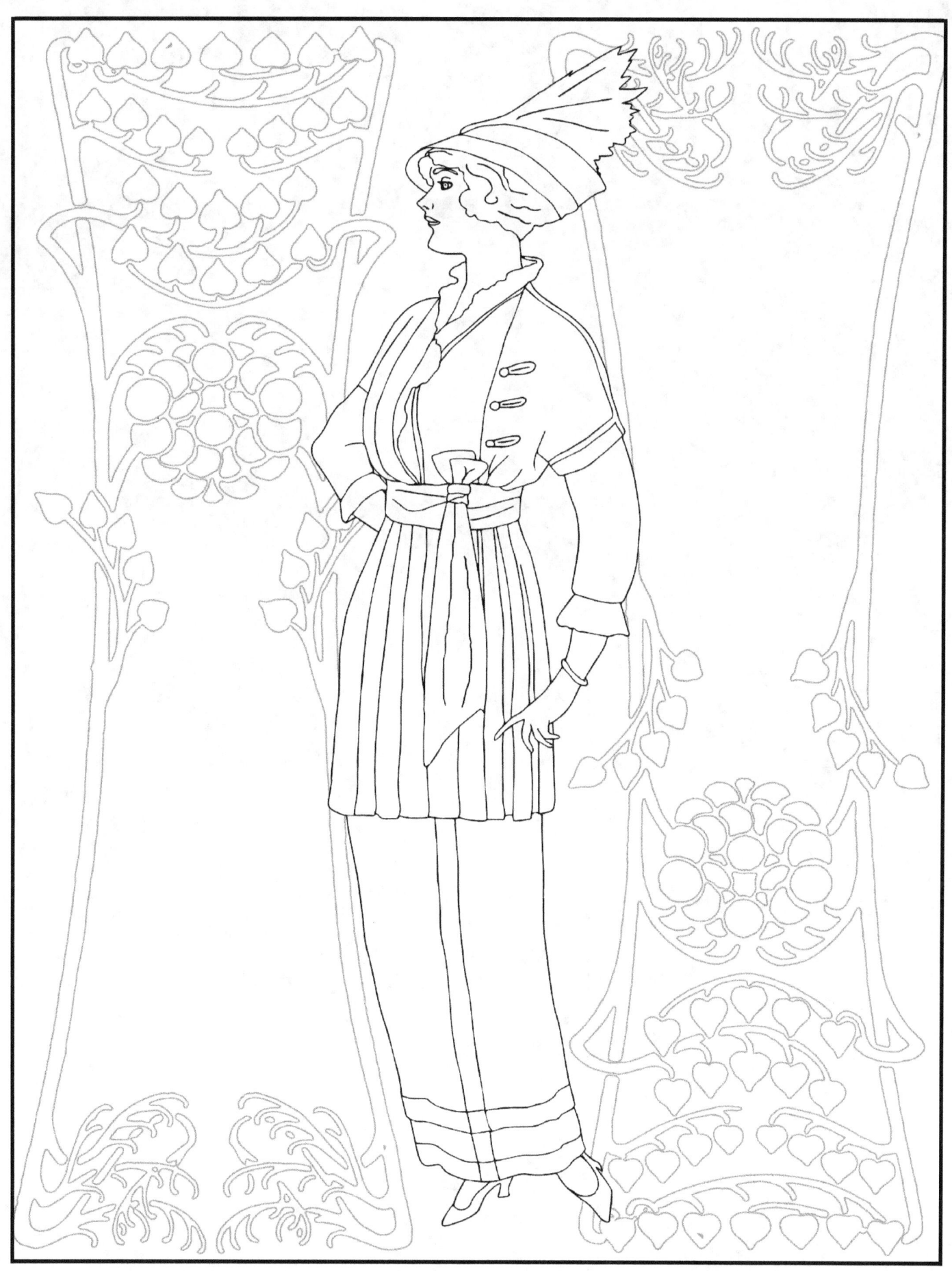

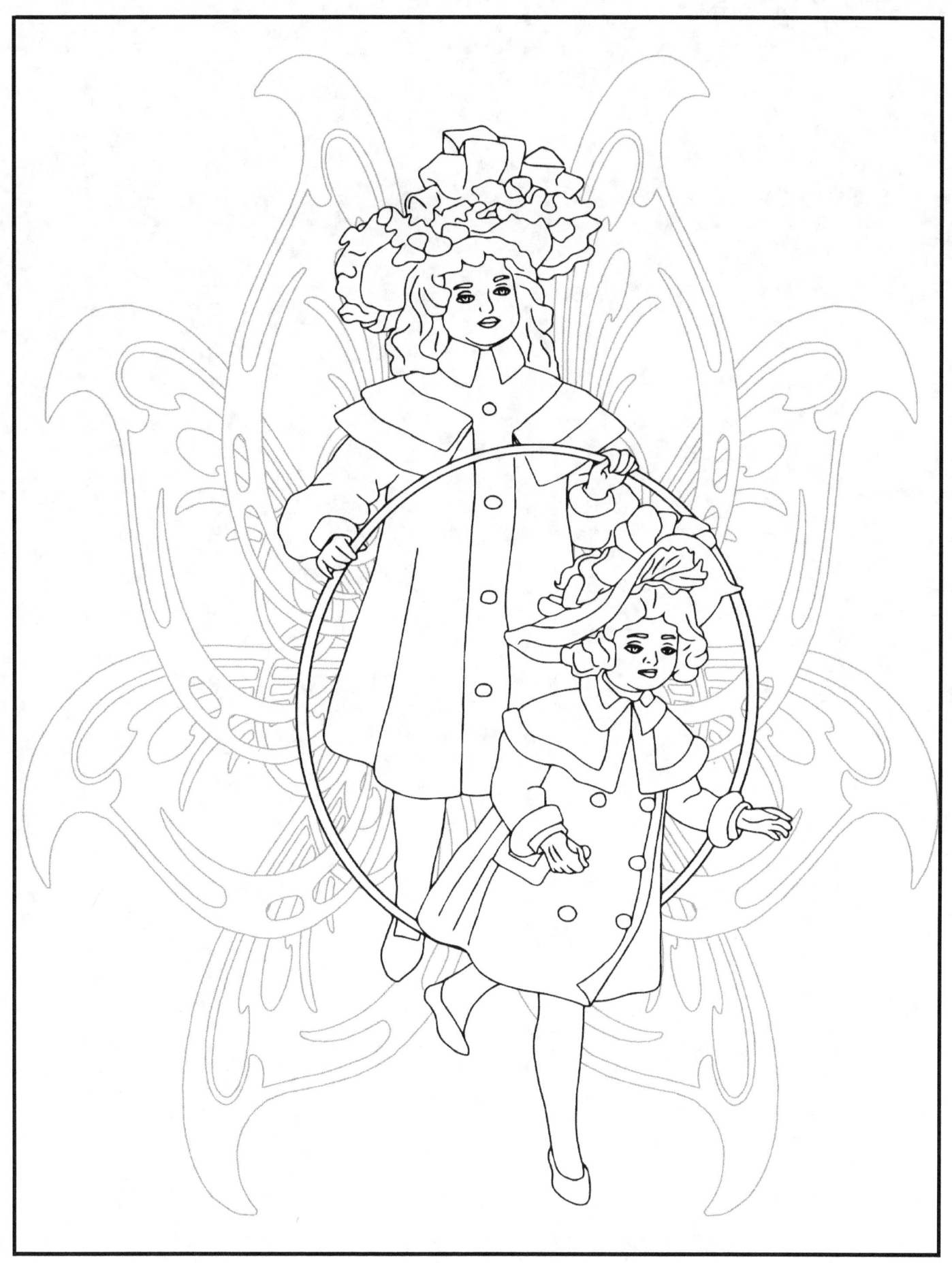

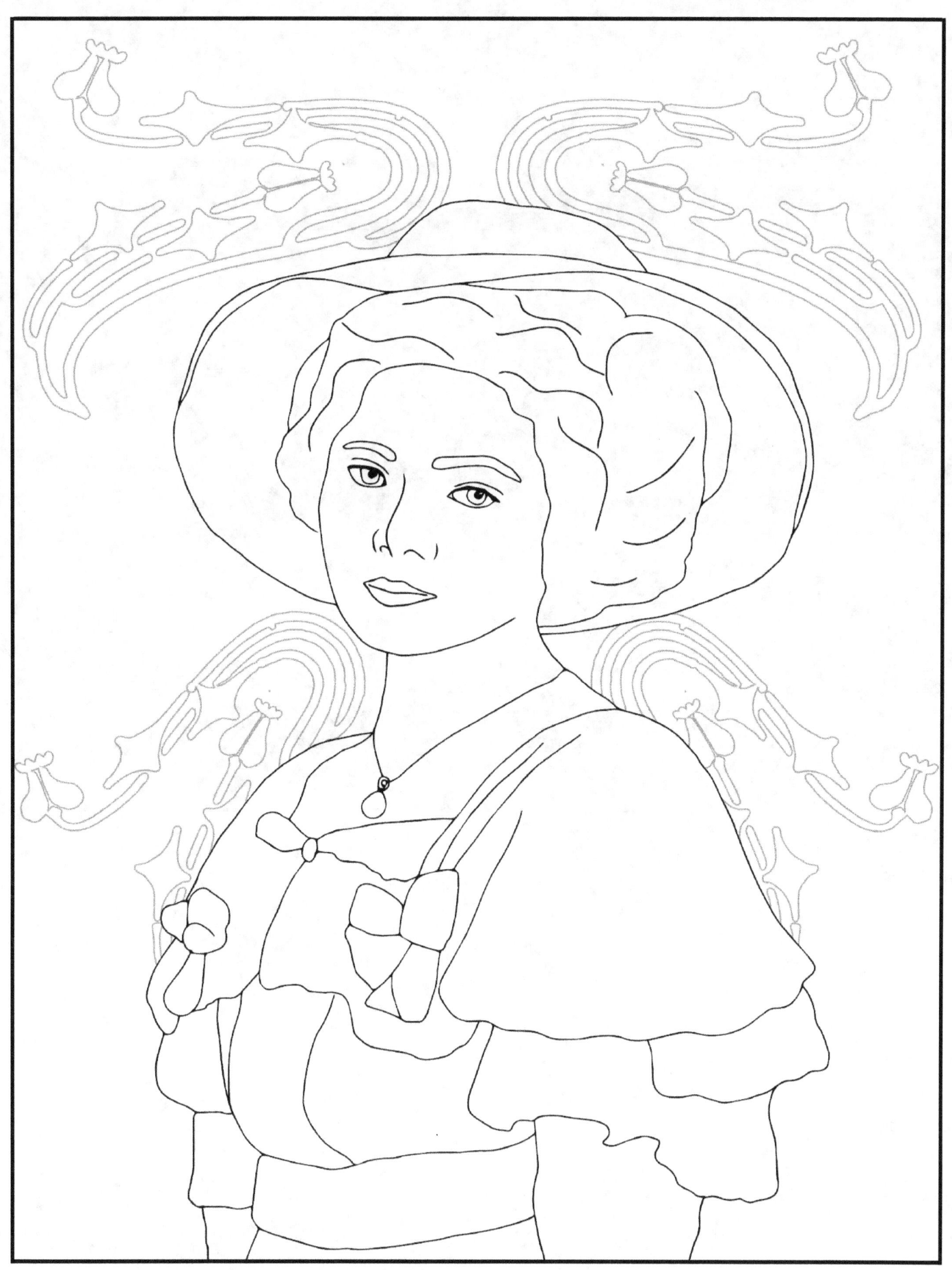

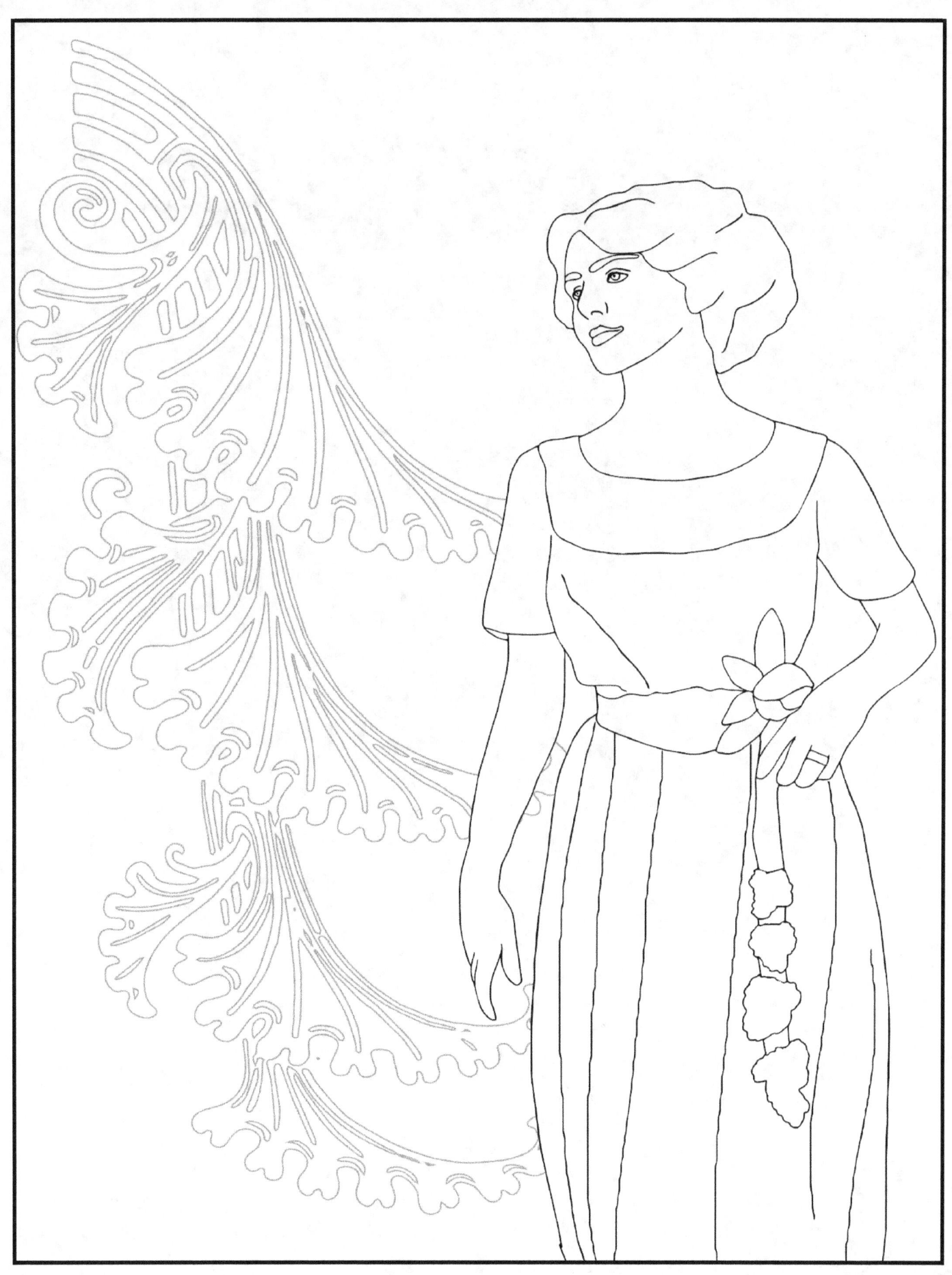

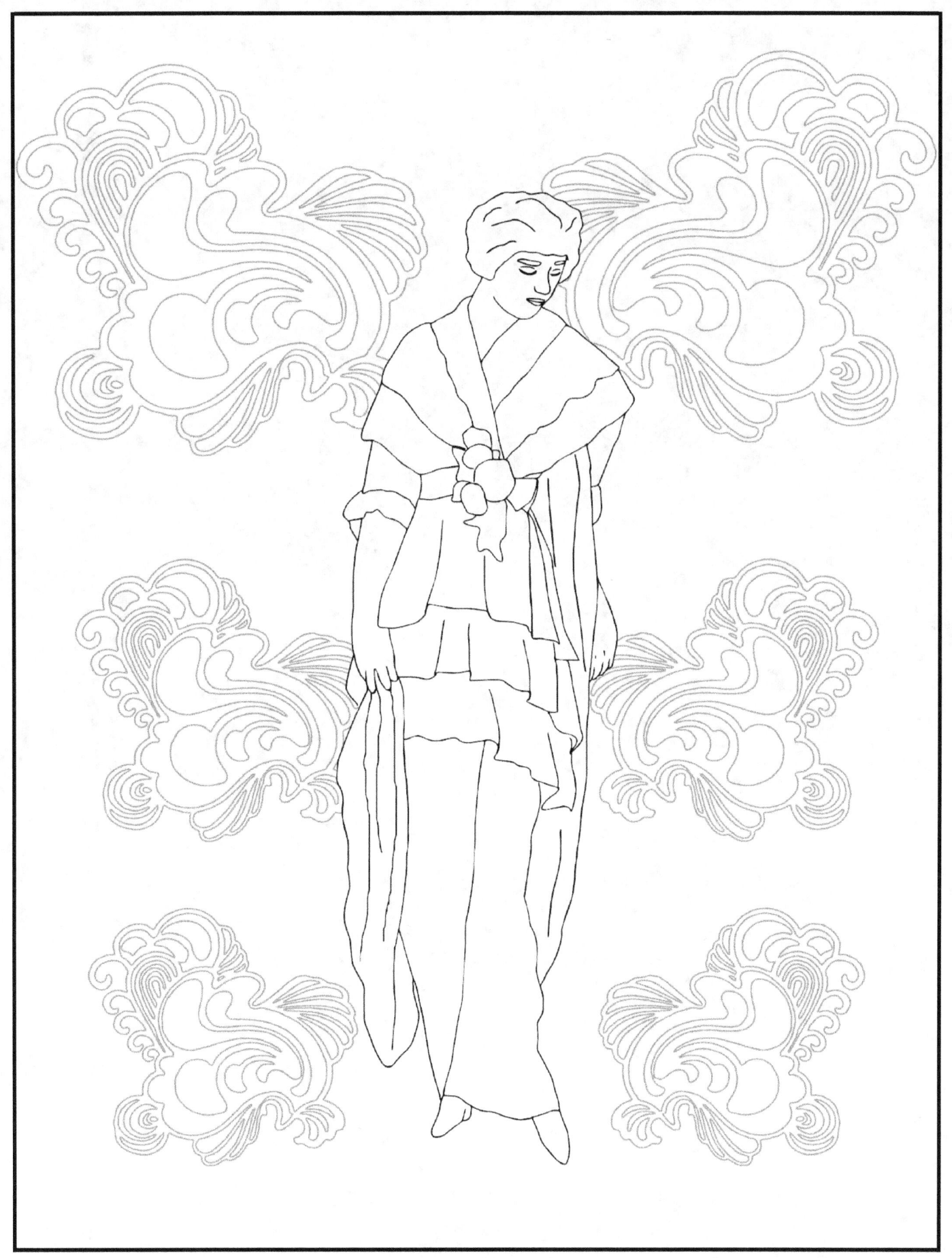

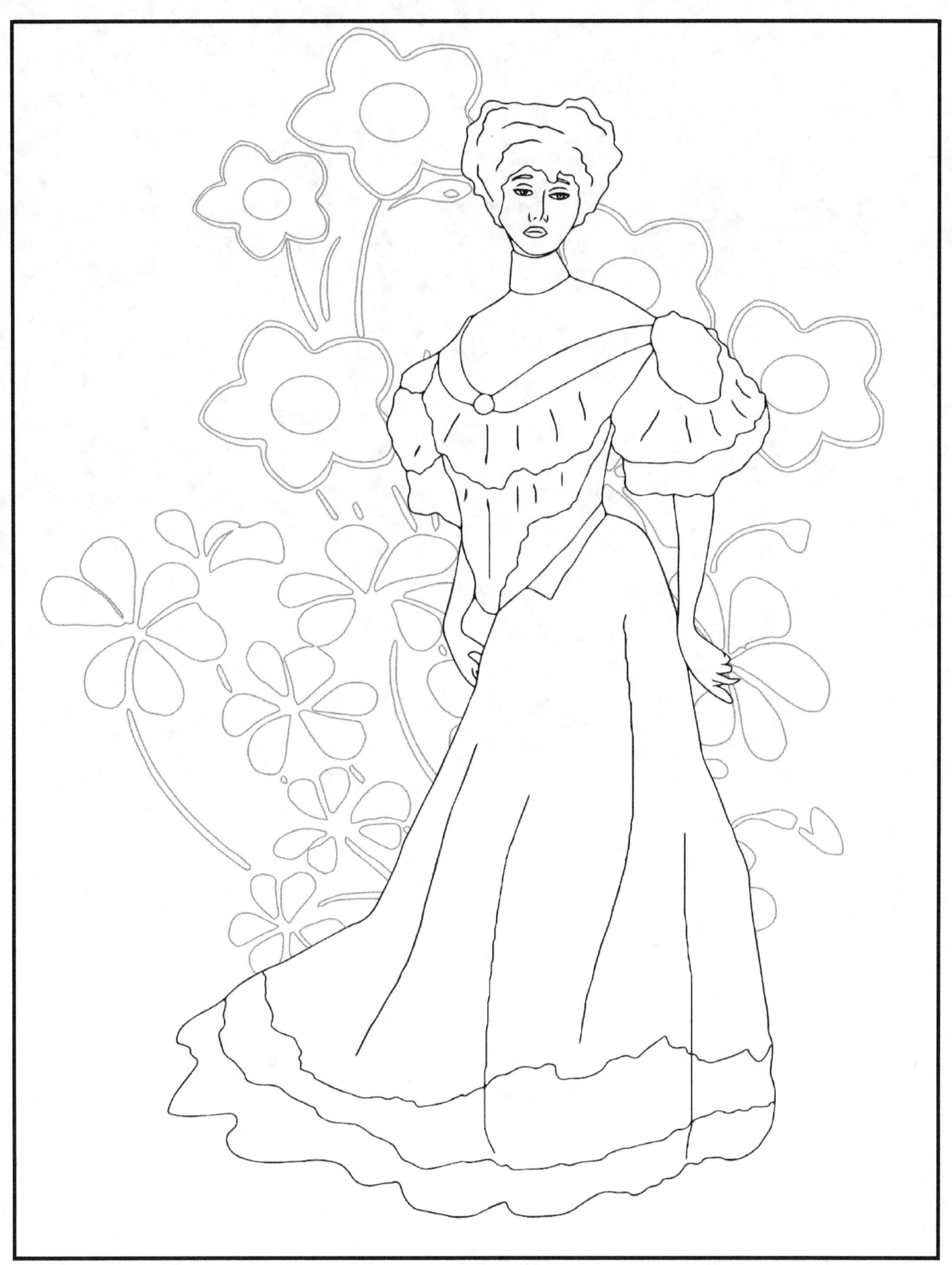

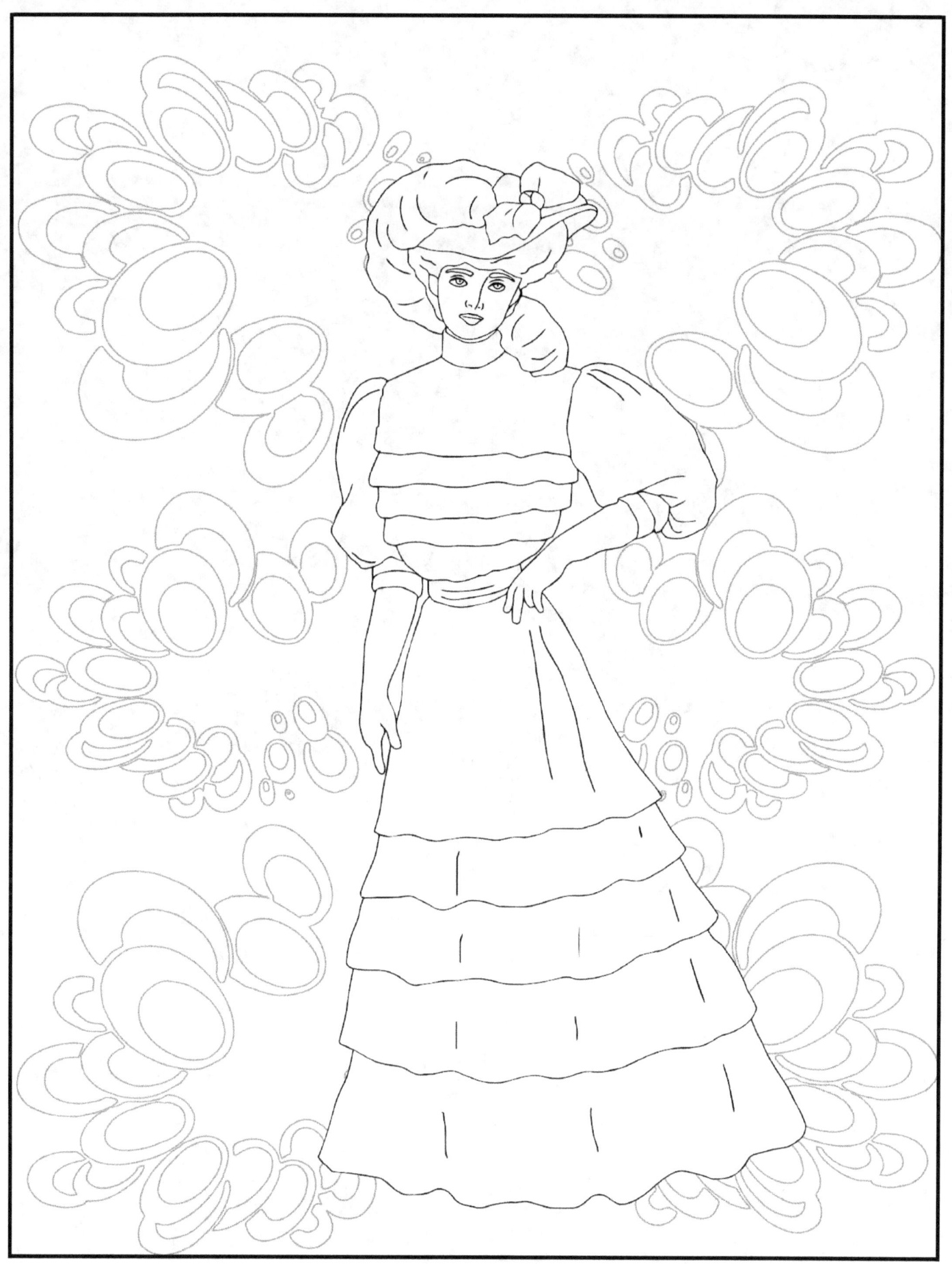

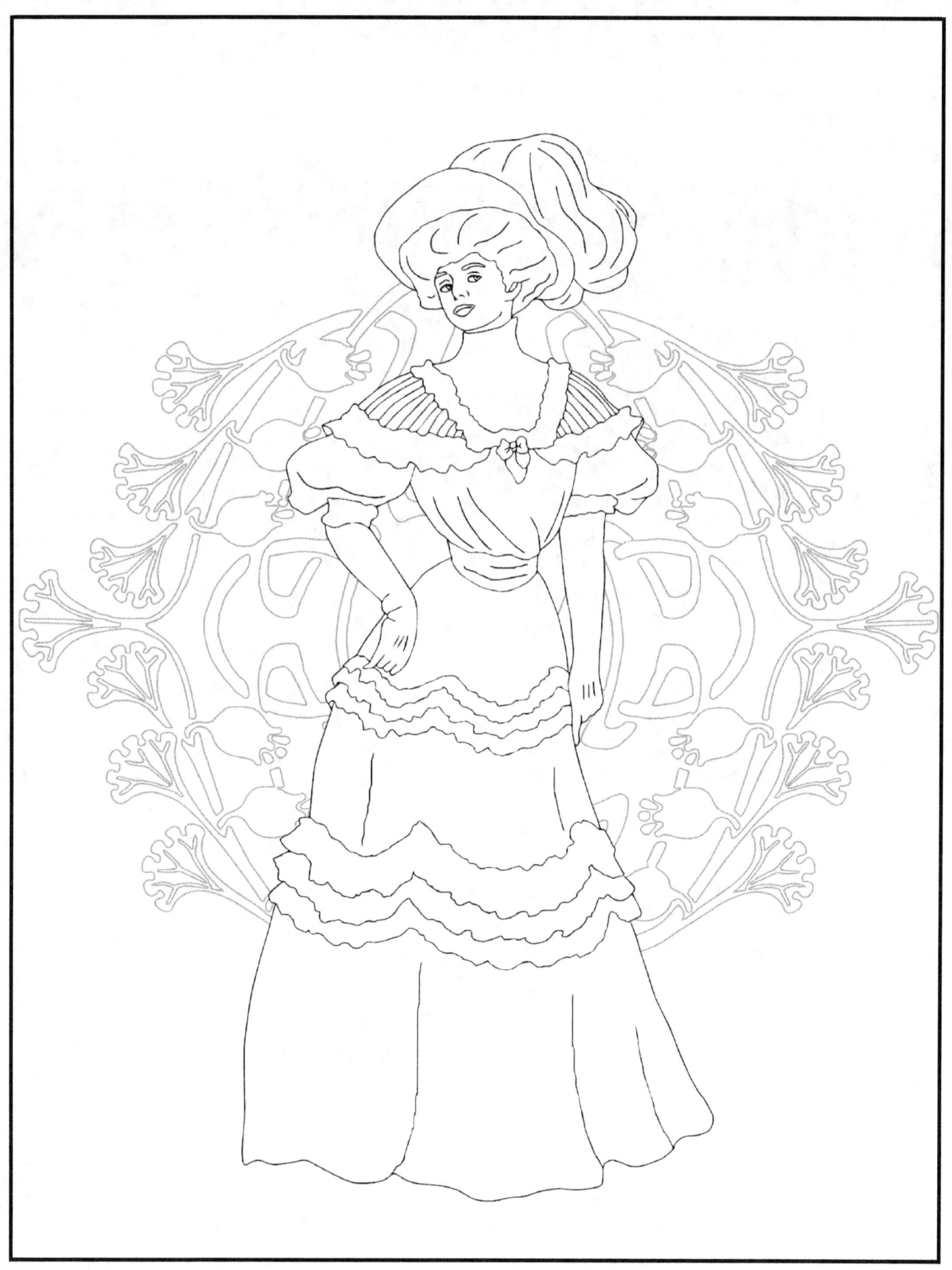

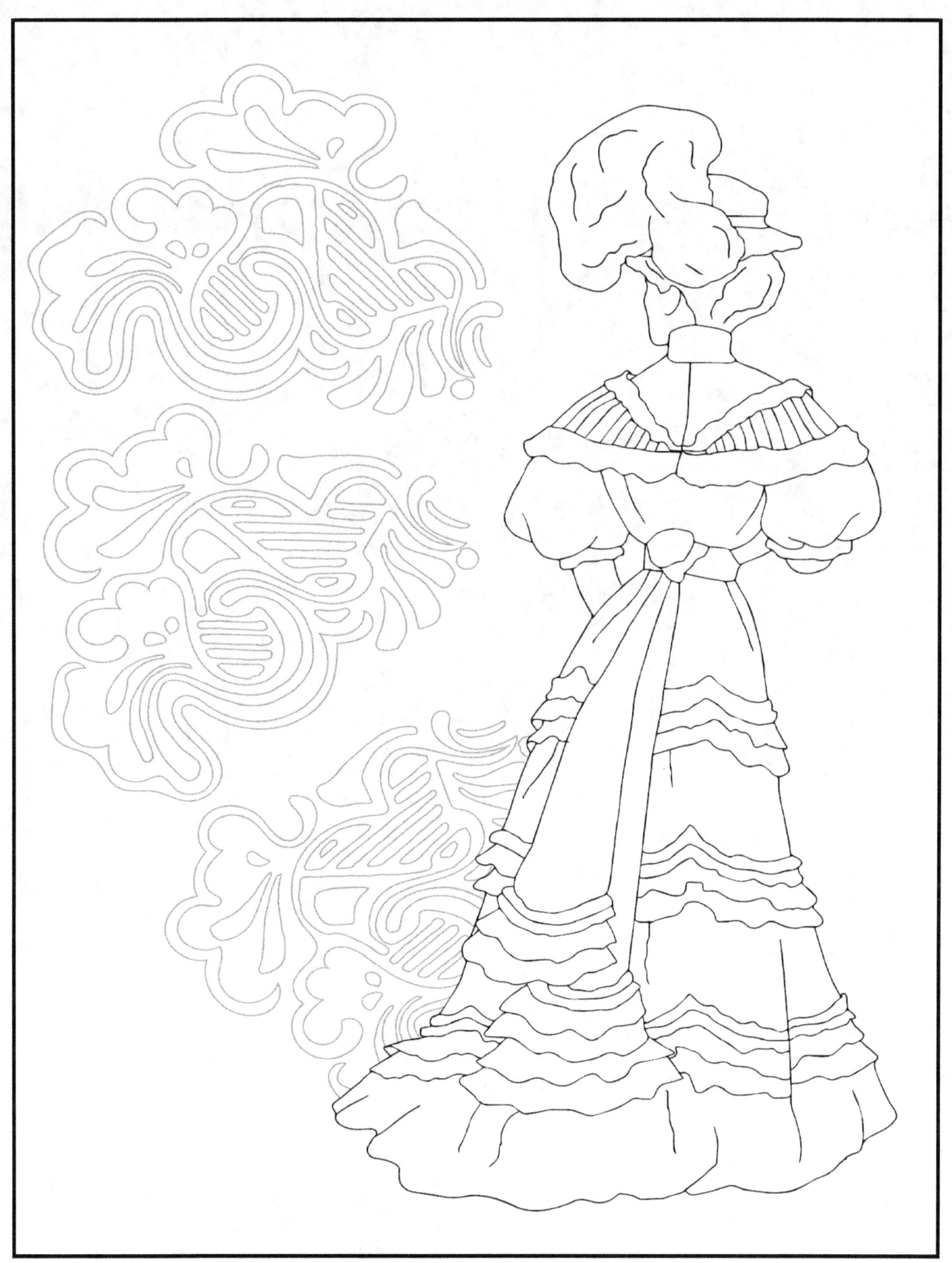

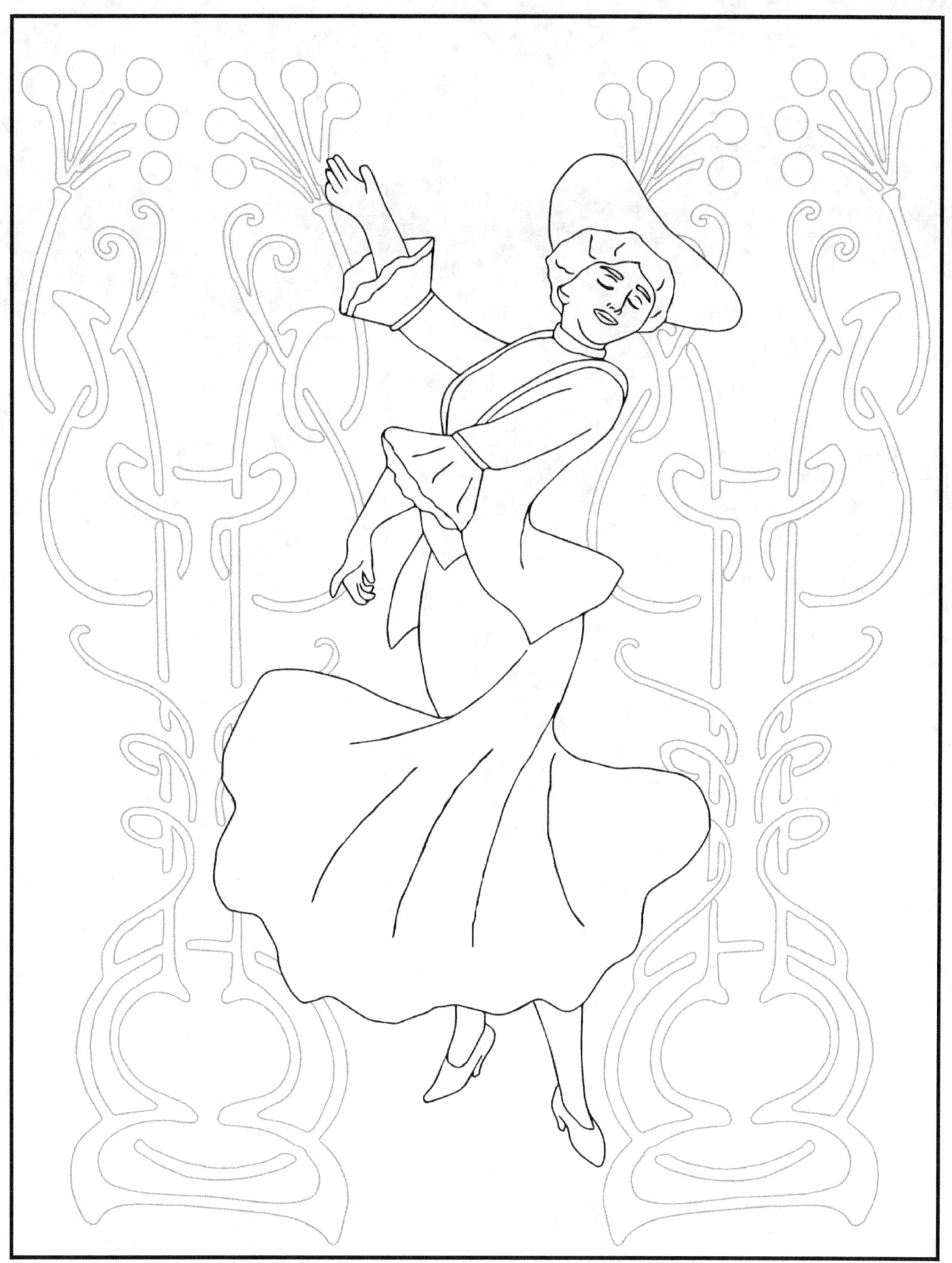

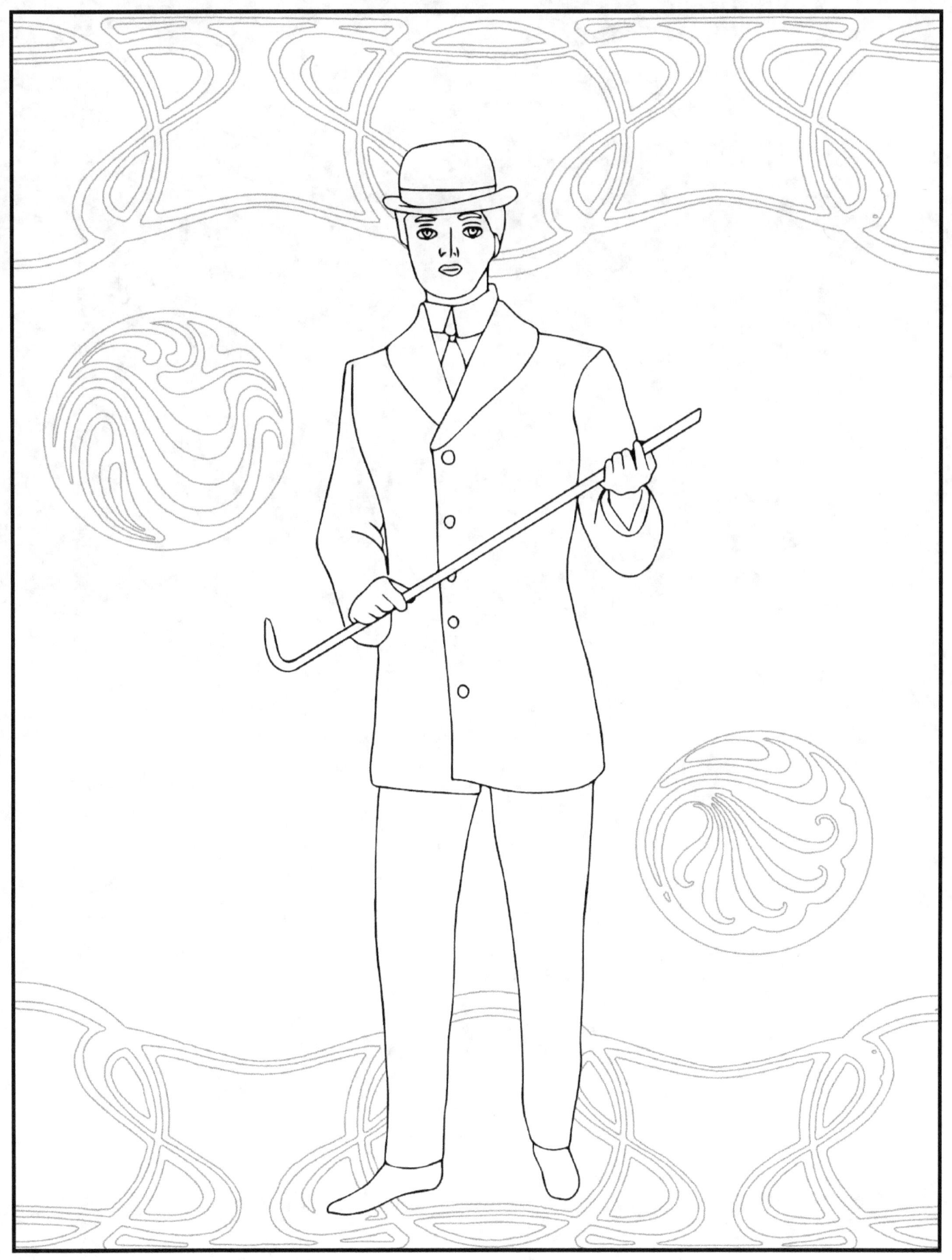

www.ingramcontent.com/pod-product-compliance
Lightning Source LLC
Chambersburg PA
CBHW081210180526
45170CB00006B/2291

* 9 7 8 1 5 2 3 4 0 1 8 6 4 *